POETRY BY CAMPBELL MCGRATH

Nouns & Verbs: New and Selected Poems

XX: Poems for the Twentieth Century

In the Kingdom of the Sea Monkeys

Shannon: A Poem of the Lewis and Clark Expedition

Seven Notebooks

Pax Atomica

Florida Poems

Road Atlas

Spring Comes to Chicago

American Noise

Capitalism

Fever of Unknown Origin

Fever of Unknown Origin

CAMPBELL McGRATH

ALFRED A. KNOPF NEW YORK 2023

THIS IS A BORZOI BOOK
PUBLISHED BY ALFRED A. KNOPF

Published in the United States by Alfred A. Knopf,
a division of Penguin Random House LLC, New York, and distributed in
Canada by Penguin Random House Canada Limited, Toronto.

www.aaknopf.com

Knopf, Borzoi Books, and the colophon
are registered trademarks of Penguin Random House LLC.

Library of Congress Cataloging-in-Publication Data

Names: McGrath, Campbell, [date] author.
Title: Fever of unknown origin / Campbell McGrath.
Description: First edition. | New York : Alfred A. Knopf, 2023. | "A Tom
Doherty Associates book."
Identifiers: LCCN 2022024587 | ISBN 9780593535721 (hardcover)
ISBN 9780593535738 (ebook)
Subjects: LCGFT: Poetry.
Classification: LCC PS3563.C3658 R33 2023 | DDC 811/.54—dc23/eng/20220525
LC record available at https://lccn.loc.gov/2022024587

Jacket photograph by Arndt Sven-Erik / Arterra Picture Library / Alamy
Jacket design by Chip Kidd

Manufactured in the United States of America
First Edition

For Elizabeth

If it catches fire it's real.

—RAINER MARIA RILKE,
"THE WORDS OF THE LORD TO JOHN ON PATMOS"

Contents

I

ODE TO HISTORY

At the crossroads
I am lost
and pull the car over and get out.
Farms as far as the eye can see,
fields of vegetables in brilliant sunlight.
No matter how hard I try
I will never create anything as beautiful as this
ripple of water
cupped in a purple cabbage leaf.
Hidden in the ditch
is a puddle
full of ducklings—fourteen
or fifteen of them
surrounding their wide-eyed mother,
while yards away,
motionless and imperturbable, stands
the great blue heron
that would snatch them
in an instant.
Always the same question,
an equation
of what is and what may be against
what has been lost—is it
worth the cost,
will it be, how could it ever *not* be?
Carefully embossed documents,

maps imbued with ancient ink, chronicles
and archives—the past
is paper
and the present a match igniting
what fires will come.

AT THE RUINS OF YANKEE STADIUM

It is that week in April when all the lions start to shine,
café tables poised for selfies, windows squeegeed
and fence posts freshly painted around Tompkins Square,
former haven of junkies and disgraceful pigeons
today chock-full of French bulldogs and ornamental tulips
superimposed atop the old, familiar, unevictable dirt.
Lying on the couch, I am drifting with the conversation
of bees, a guttural buzz undergirding the sound
from a rusty string of wind chimes hung and forgotten
in the overgrown beech tree marooned out back,
limbs shaggy with neon-green flame-tongue leaflets
forking through a blanket of white blossoms,
long-neglected evidence of spring at its most deluxe,
pure exuberant fruitfulness run amok.
Rigorous investigation has identified two dialects
buzzing through the plunder-fall, hovering black bumblebees
and overworked honeybees neck-deep in nectar-bliss,
as the city to us, blundering against its oversaturated anthers
until the pollen coats our skin, as if sugar-dusted,
as if rolled in honey and flour to bake a cake
for the queen, yes, she is with us, it is spring and this
is her coronation, blossoming pear and crab apple
and cherry trees, too many pinks to properly absorb,
every inch of every branch lusting after beauty.
To this riot of stimuli, this vernal bombardment
of the senses, I have capitulated without a fight.
But not the beech tree. It never falters. It is stalwart
and grounded and garlanded, a site-specific creation,

seed to rootling to this companionable giant,
tolerant and benign, how many times have I reflected
upon their superiority to our species, the trees of earth?
Reflection, self-reflection—my job is to polish the mirror,
to amplify the echoes. Even now I am hard at work,
researching the ineffable. *I loafe and invite my soul,*
for Walt Whitman is ever my companion in New York,
thronged carcass of a city in which one is never alone
and yet never un-nagged-at by loneliness, a hunger
as much for the otherness of others as for the much-sung self,
for something somewhere on the verge of realization,
for what lies around the corner, five or six blocks uptown,
hiding out in the Bronx or across the river in Jersey.
Somewhere on the streets of the city right now somebody
is meeting the love of their life for the very first time,
somebody is drinking schnapps from a paper sack
discussing Monty Python with a man impersonating a priest,
someone is waiting for the bus to South Carolina
to visit her sister in hospice, someone is teleconferencing
with the office back in Hartford, Antwerp, Osaka,
someone is dust-sweeping, throat-clearing, cartwheeling,
knife-grinding, day-trading, paying dues, dropping a dime,
giving the hairy eyeball, pissing against a wall,
someone is snoozing, sniffling, cavorting, nibbling,
roistering, chiding, snuggling, confiding,
pub-crawling, speed-dating, pump-shining, ivy-trimming,
tap-dancing, curb-kicking, rat-catching, tale-telling,
getting lost, getting high, getting busted, breaking up,
breaking down, breaking loose, losing faith,
going broke, going green, feeling blue, seeing red,
someone is davening, busking, hobnobbing, grandstanding,

playing the ponies, feeding the pigeons, gull-watching,
wolf-whistling, badgering the witness, pulling down the grille
and locking up shop, writing a letter home in Pashto or
Xhosa, learning to play the xylophone, waiting for an UberX,
conspiring, patrolling, transcending, bedeviling,
testifying, bloviating, absolving, kibitzing,
kowtowing, pinkie-swearing, tarring and shingling,
breaking and entering, delivering and carting away,
enwreathing lampposts with yellow ribbons,
reading Apollinaire on a bench littered with fallen petals,
waiting for an ambulance to pass before crossing First Avenue
toward home. No wonder they fear it so intensely,
the purists and isolationists in Kansas, the ideologues
in Kandahar, it is a relentless negotiation with multiplicity,
a constant engagement with the shape-shifting mob,
diversely luminous as sunlight reflecting off mirrored glass
in puzzle pieces of apostolic light. Certainly this is not
the Eternal City but it is certainly Imperial, certainly
tyrannical, democratic, demagogic, dynastic, anarchic,
hypertrophic, hyperreal. An empire of rags and photons.
An empire encoded in the bricks from which it was built,
each a stamped emblem of its labor-intensive materiality,
hundreds of millions barged down the Hudson each year
from the clay pits of Haverstraw and Kingston
after the Great Fire of 1835, a hinterland of dependencies,
quarries and factories and arterial truck farms
delivering serum to that muscular heart, a toiling collective
of Irish sandhogs and Iroquois beam walkers and Ivorian
umbrella vendors collecting kindling for the bonfire
that has lured, like moths, the entire world to its blaze.
As with my tree, the hubbub of bees its exaltation.

Apis, maker of honey, *Bombus,* the humble bumbler,
and the tree a common American beech.
It rules the yard, overawing a straggling ailanthus
hard against the wall of the ConEd substation.
Along the fence some scraggly boxwood shrubs,
a table collapsed into rusted segments, two piles of bricks—
what's their story?—who made them, carted them,
set them as a patio, and who undid that work to create these
mundane, rain-eroded monuments to human neglect?
Why does nobody tend this little garden?
Undisciplined ivy scales the building in thick ropes
and coils of porcelain berry vine, whose fruit will ripen
to obscene brilliance come autumn, those strange berries,
turquoise, violet, azure . . . Ah, I've lost my train
of thought. Berries. The city. People, bricks, the past.
Bees in a flowering beech tree. Symbiosis. Streams and webs
and permutations, viruses replicating, mutating, evolving.
Books in a library, bricks in a wall, people in a city.
A man selling old golf clubs on the corner of Ludlow Street.
A woman on the F train carefully rubbing ointment
up and down her red, swollen arms. Acorns—
tossing them into the Hudson River from a bench as I did
when I was Peter Stuyvesant, when I was Walt Whitman,
when we were of the Lenape and Broadway our hunting trail.
Then the deer vanished, the docks decayed, the towers fell.
The African graveyard was buried beneath concrete
as the memory of slavery has been obscured by dogma
and denial. The city speaks a hundred languages,
it straddles three rivers, holds forty islands hostage,
an archipelago of memory, essential and insubstantial
and evasive as the progeny of steam grates at dawn,

a congregation of apparitions. The Irish have vanished
from Washington Heights but I still see myself eating
a cold pot-roast sandwich, watching *McHale's Navy*
on black-and-white TV in my grandmother's old apartment.
I remember the parties we used to throw on Jane Street,
shots of tequila and De La Soul on the tape deck, everyone
dancing, everyone young and vibrant and vivacious—
decades later we discovered a forgotten videotape
and our sons, watching with bemused alarm, blurted out,
Mom, you were so beautiful! She was. We all were,
everyone except the city. The city was a wreck and then
it was a renovation project and now it is a playground of privilege
and soon it will be something else, liquid as a dream.
Empires come and go, ours will fade in turn, even the city
will retreat, step by step, as the Atlantic rises against it.
But water is not the end. Bricks are made of clay and sand
and when they disintegrate, when they return to silt,
new bricks will be made by hands as competent as ours.
People will live in half-flooded tenements, people will live
on houseboats moored to bank pillars along Wall Street.
It's all going under, the entire Eastern Seaboard.
The capital will move to Kansas City but nobody will mourn
for Washington. Someone will invent virtual gasoline. Someone
will write a poem called "At the Ruins of Yankee Stadium"
which will be set to a popular tune by a media impresario
and people in Ohio will sing it during the seventh-inning stretch
remembering, or imagining, the glory of what was.
Time is with us viscerally, idiomatically, time inhabits us
like a glass bowl filled with tap water at the kitchen sink,
and some little pink stones, and a sunken plastic castle
with a child's face etched in a slate-gray window.

Fish swim past, solemn as ghosts, and the child smiles sadly,
wondering, perhaps, how bees will pollinate underwater.
He seems a little melancholy. He must miss his old home,
a skin-honeyed hive of multifarious humankind,
a metropolis of stately filth doused in overrich perfume.
The castle door swings open and the boy emerges
like an astronaut stepping warily onto the moon.
When he sees us, through the warping lens of the bowl,
watching him with desperate, misfocused passion, we are
as cartoonishly gargantuan as the past, and he as spectral
as the future, raising one small hand to wave goodbye.

THE PARKING LOT

Where has all the time I inhabited,
like a minnow in a stream,
vanished to? Collected in calm pools
among boulders, I like to imagine,
as where waterfalls chimed away the spring
before the stillness of late autumn.

And who are you, imperious maker
of minnows, bells and water,
all this your exacting handiwork,
solid as the stones in these temple walls,
mysterious as the boundary that divides
noise from music,
adoration from common prayer.

2.

I apprehend myself of a sudden,
crossing some open space—the parking lot,
denuded asphalt like a desert plain
hard-ridden by Comanches—I come to myself,
shuttle into focus, bus engines idling,
a flowering tree on the berm
not yet ready to relinquish its blossoms,
that single note
of beauty—I resolve out of the haze

and back into this,
my body. Sun pouring down,
slots filled with gleaming automobiles,
the absolute plainness
and calmness of it—a recognition,
an animating awareness.
And an aftershock, like a gong,
which, having sounded its brave reverberation,
echoes infinitesimally to silence.

3.

Days from now, years from now,
there will be a war
inside of me
to recollect this moment.

I will lose.

THE MOON

Light delimits the darkness as snow
gives shape to the silence of winter trees.
Above a rooftop, the shadow of illness hovers
indistinguishable from the wraiths
of common chimney smoke.
Strip skin from flesh, flesh from bone
to behold the comical, adumbrative skeleton,
rickety ladder to the ore-cask of the skull,
crude keys to forgotten locks.
Surely, this cannot be the answer,
this calcified puzzle-works,
this unmarked instant ticking to dust
even as I seek its delay, letting it crawl
up a finger to my wrist, like an ant.
How luxurious the world's materials,
and such illumination—moonlight
revealing every inch of a table so familiar
it could only be your mother's kitchen.
And the ant, laboring to cross that plateau,
what part of you desires to crush it?
Not the hapless thumb,
not the bicep, which lacks agency,
not even the mind, which admires industry,
and understands harmlessness, and professes
fellowship with insignificant creatures.
Only the heart could be so miserly,
begrudging the ant its morsel of sugar,
pure and selfish as the moon.

NIGHT AND DAY

Day is as simple as the body,
night is like the mind.
Day is water, night is wine.

Day is a flock of sparrows,
night is an owl.
Day is a consonant, night is a vowel.

Night is the sacred cat of the Egyptians,
day is a dog, any old dog.
Night is salt in the day's wide ocean.
Day is bread, night is fog.

THE FROG POND

Late July and the grass rises waist-high, leonine,
straw and russet running down the little hillside meadow
to the frog pond where the night egret lurks
but the frogs are silent now, hidden
in the weeds from the sun and other unmerciful eyes.
Across the road the cornfields are lush and delectable
though the milk cows that blanketed the hillsides are long gone,
it's become a corporate business, dairy farming,
and the old family pastures have been repossessed by trees.
The forest is a voracious, green-leafed glacier.
And the frog pond gleams
in sunlight, a mirror the color of oak roots,
a slab of rain-wet shale lightly sheathed in moss.
Not yet time to swim, but it awaits.

After the rain the pond smells like birdseed.
Or maybe that's seed-dust from the feeder on my hands,
I've refilled it so the blue jay can chase away the cardinals
while the cheeping songbirds steal whatever spills
or overflows. Birdseed and copper pennies.
Soil, minerals, lemon, cedar. Pine-Sol cleanser—
gray water in the bucket after mopping the cabin floor!
Of course, these are all smells from my childhood,
so perhaps I am merely remembering the taste
of Poconos lake water and associating it forward,
or back? Nostalgia is time's double agent.

At least it does not smell like Hawaiian Punch. Not yet.
The pond is home to a pair of plump golden grass carp
and a swarm of little mud-colored minnows
and hosts of gorgeous black-and-violet dragonflies
and vivid, orange-red damselflies. The slenderest damsels
raft around on twigs and leaves, one per vessel,
and zoom away as I approach them, eye to eye.
Sometimes one lands on my head, mistaking me
for what—a lotus blossom? A moose? A golden carp?

Jumping in: sound of water, slap of impact,
liquid membrane against my own, skin to skin.
The pond is a layer cake, warm as a sun-heated tub
at the surface, cool and murky in the middle,
while the spring-fed depths remain bone cold,
chthonic, unyielding as granite. It starts to rain again.
Drops pock the surface and I try to catch them in my mouth.
Floating on my back I watch one final cloud
coming over the mountain after the front has galloped past,
leaving the crowns of the trees a rough silver-gray
in storm-slanted light. Poor little cloud, it is shrinking
away, smaller and smaller, my sheepish straggler,
down to the vanishing point—and gone,
atoms dispersed into the atmosphere, unlamented,
and unrecorded, I suppose, by any eyes but mine.

2.

Before lunch a flock of wild turkeys traipse through the yard
like a posse of tiny dinosaurs, patrolling stealthily
through the tall grass, head up, head down,
gangling, straggle-feathered, dingy but not undignified.
A *rafter* of turkeys, some would have it, rather than a flock,
though of course those compound nouns are a crock
invented to delight weakling imaginations,
a *murder* of crows, an *exaltation* of malarkey—
this was a purebred American turkey mob,
seven or eight gray-scale chicks able to vanish instantly
into the tawny meadow grass at the slightest sound,
like special ops forces on a recon mission.
Four or five middling ones, the largest alone out front—
is it a harem and only one male, is that how it works?
Naughty birds. Pecking and neck-bobbling,
obeying their arcane protocols,
they traverse the hill and disappear into the woods.

"Bird TV," Elizabeth calls it, watching our airy neighbors
from the big sliding windows of the sunroom,
paired doves, the great blue heron, vultures circling the ridge.
Yesterday we noticed three small, eye-catching birds
in the meadow, their wings the bright yellow
of October maple leaves, their identity a mystery
until one perched carefully atop a bristling purple thistle,
exactly as described in the Audubon guide
for the American goldfinch. So there it is. And there they go,
swooping to the branches of the mulberry tree,

where, some afternoons, the imperturbable woodchuck
trundles from his streamside thicket to gobble fallen fruit.

Right now, two robins are yanking worms from the ground
like taffy, a small and exotic act of savagery.
How, without hands, do the earthworms hold on so long,
stubborn as truth, against such ruthless predators?
How do the robins know where to find them?
Can they hear them tunneling beneath their feet,
do they ask the grass for a tip-off?
Everything is alive and hungry and burning and maybe
everything is speaking a language
we are ill-equipped to understand, thistle, dandelion,
alder shoots and pinecones, glorious trees inflamed by sunlight,
their leaves are the pages of books,
illuminated manuscripts shelved in the sun's library,
a record of its celestial burning, and of ours,
which is entirely earthly—the radiance archive—
each life, each creature, each instant, each sunbeam
fuel for time's unfolding inferno, time's uncontainable wildfire,
or is it a waterfall, a rising tide, a river? Or is it
a frog pond? Is it?
I'm not sure, but the frogs continue to voice
strong opinions on the matter.

3.

Heavy fog at five a.m., clear and blue when I step outside
to a world overwritten with silver spiderwebs.
Everywhere you look, across the mown grass of the hilltop,
tentlike webs glow in morning sunlight,
pearlescent with mist. If not for the weather, who'd know
so many hardworking citizens lived among us?
Either the spiders hold a council and decide to weave
with extra fervor on foggy nights, or they are
always spinning and tenting, laboring invisibly to capture
their slim, sustaining measure of the insect universe.
On the deck, caterpillars are devouring the potted parsley
while yesterday's candles, rehardened but still translucent,
resemble catacombs jammed with mummified remnants
of mosquitoes, mayflies, small papery mothlets
and one large, elegant moth,
its tortoiseshell wings entirely entombed in wax.

Sat out beside the firepit last night as the fireflies
challenged the planets for supremacy, Jupiter
in the southern sky, Venus setting early in the west.
Mars will not be this close again for 269 years,
astronomers say, and who are we to doubt them?
Brilliant and red-eyed it rises through the pines, blinking
like an infant cyclops, and I can only imagine
how jealous it feels, gazing upon our beautiful world.

Every day for a month I've swum in the frog pond,
every night the moon has grown larger, and now

it is full, late-risen to render the stars an afterthought
and the meadow a lambent, noctilucent tapestry.
One complete cycle in a month, twelve in a year,
which means you could witness a thousand in a lifetime
of eighty-three years, not an unrealistic projection.
One thousand full moons. So many. So few,
and already I've squandered scores to clouds
and city lights and the enormous shadows
of sleeping children—oh, just then it flashes past,
barely brushing against my shoulder in the darkness,
an owl or a bat or a touch from the wing tip
of some enchanted creature, ogre or princess,
a caress from the vanishing hand of time.

Mythological beings do not trouble my sleep
though the barn owl's ululations can, and the yelps
of coyotes we hear sometimes before sunrise.
But every night the frogs keep up a maniacal racket,
howling like monkeys from dusk to dawn,
plucking away at their slack-stringed banjos,
a cacophony of croaks, blurts and bellows
like the bugling of a diminutive green elephant.
In fact they are smallish fellows, a native species,
unimaginatively named *green frogs*, the book says,
though some appear silvery gray, like brined olives,
others green–gold in the sunlight,
barely distinguishable from the fallen linden leaves
along the little pathway to the pond. Falling asleep
their babble sounds exactly like two men
talking loudly just beyond the frontier of coherence,
two men yelling on a subway platform as the train arrives,

two men at a bar speaking urgently over the noise
of a karaoke singer in back or the Yankees game on TV.
Loud, insistent, important, certainly it's important.
But you can't quite catch it, *what?*—sitting up
in bed—*what? what is it?* Nothing
but the frogs carrying on
their unresolvable argument with the night.

SANTA MONICA

Five o'clock on a crisp, star-clear winter evening,
sun just sunk beneath the oyster-blue Pacific Ocean,
a panoramic swath of reflective foil rippling incessantly
as if ants were crawling everywhere across it.
Coastward, the dramatic graph line of the Malibu hills
diminishes with distance to the north and west, so that
the underlying equation of which it is an expression
depicts a miraculous rise of improbable good fortune,
an ascent that crowns the city in laurel-scented peaks.
Somewhere in this deco matrix someone is having great sex
with a Ukrainian model hoping to become a movie star,
and someone is getting ready to rob a liquor store,
but mostly the TVs are on, domestic window lights
casting their guppy-blue glow against unforgiving hills.
Sky toning down now toward melon-rind and umber
from the citrus colors of a moment ago—they move
that fast, our lives, downshifting, gradation to gradation,
tone to tone within the forward-shooting thrust of
whatever it is, time, the cosmos, magical afterwash
of the Big Bang carrying us toward a tide line
patrolled by black-cowled palm trees and taillights
along the Pacific Coast Highway. Science,
that madness, propels an airplane toward landing,
wing lights bright as signal flares, lest we forget
to believe in the dream of technology, and it plummet.
Thus they gaze down upon us, the dead from their ether
and the living through egg-shaped plastic windows—

the dead to admire the seams of the nation shining
with fossilized carbons, while the living configure secret
dioramas of cinematic expectation in the half-dark,
dragonflies caught in the soft amber of imagination,
sea anemones opening and closing with the tide,
the twin sisters seated in 23D and E giggling at the memory
of the grass-scented tongue of a giraffe wrapping
around their wrists at a zoo in a departed city, the patterned
mimicry of its torso, the hieratic neck, tall as a rocket,
and the smaller shuttle craft that will one day
carry settlers to the earth-ready rim planets of Tau Ceti.
What will they know of the giraffe in those mercurial worlds?
What will they know of anemones, or gasoline, or snow,
of waking in a Paris doorway just before dawn,
of how, in Chicago, in order to make bookshelves
we visited the loading dock behind the supermarket at three a.m.
to steal milk crates made from indestructible orange plastic,
then borrowed a half-dozen planks from a construction site
to erect a simple altar to Plato, Dostoevsky, Saint Augustine.
And now the passage to another world slides open
as the celestial tumblers align, each star its own wishing well,
its own penumbral shaft we could climb with a rope ladder,
or descend, if only, but it is just a momentary glimpse,
the portal has already closed upon immaculate indigo
California twilight with every beauty that implies.
Dark script of waves, dark lines of breakers advancing
without foothold. Regret has no purchase here.
It resides with the balms and toxins in canopic jars
protected by spells beneath a boy pharaoh's pyramid.
Smoke rises from the censers of holy men along the Nile,

perfume and unguents in the cathedral at Hippo,
murmur of voices as the shaman steps into the firelight
armed with three weapons to hold back the darkness—
a dagger carved from reindeer antler,
an amulet in the shape of a woman's body,
the words of an incantation learned in a dream.

TUGBOATS ON THE CHICAGO RIVER

The lights we see at night—the stars—are like tinsel on a
 Christmas tree or snow on sleeping mountains,
revealing by implication the contours of a vast, dynamic
 emptiness, modeling the unseen body of the universe.
Time has a shape, elusively glimpsed by cosmologists and
 quantum physicists in their baroque equations
but long known to the homeless men asleep on cardboard shunts
 in the alleys between State and Wabash.

As if this life did not provide enough good excuses for murder,
 people are killing each other over the nature of divinity,
people are being killed, as we speak—if this is, in fact, a form of
 speech—over sacred mysteries
from which we distance ourselves with vigorous industry,
 thoughtless rapacity, and accidental grace.

Even now, as you stumble past these words, tugboats are hauling
 rusty barges along the Chicago River.

BURNING THE SHIPS

Burning the ships on the beach, as Cortés did after disembarking
 upon the shore of that savagely-flowered mysterium,
made evident to his wide-eyed men that this New World was theirs
 for the taking and retreat was not an option,
no matter the brilliance of the hummingbirds, no matter how
 shocking the enemy with their poison darts and imprecations,
much like my own urgent whisperings to our newborn son that
 first morning in Chicago: *Welcome,* and, *There is no going
 back.*

2

FEVER OF UNKNOWN ORIGIN

<div align="center">I.</div>

A storm of buzzards is circling outside the window
of my hospital room, looking south and east across the river
toward the high-rise construction cranes downtown.
They are a regular sight in December, buzzards migrating
in particulate vortices, slow-moving gyres that resemble,
from a distance, glassless, black-feathered snow globes.
Satin-hemmed sheaths of cloud shuttle across the sky,
diffuse silver light alternating with bursts of Florida sun,
the occasional spatter of raindrops from a string
of unseasonable storms parading up from the Gulf,
cars composing a stop-and-go stream of metal
parallel to the river, small Caribbean freighters docked
along quaysides of cabbage palms and crab traps,
I can see it all with great clarity, the birds, the traffic,
it's effortless—the doctor in the eye clinic
spoke enviously of my vision, better than 20/20,
even at my rapidly-advancing middle age.
The bad news is that I am periodically blind
in one of those otherwise excellent eyes, which flickers
between darkness and light, like poorly-connected cable TV.
It's terrifying, that darkness. Enveloping. Confounding.
Immediately, all thought flows toward the remaining eye—
may it never falter, dear Lord, may it guide me
through the corridors of your mansion forever and ever,
amen. In the land of the blind the one-eyed man is king
but I have never envied royalty. I am a democrat

and I want to go home. It's two days before Christmas
here at the ho-ho-hospital, and the nurses are antsy
for some quality family time, Becky has four girls
and a worthless ex-husband, she started nursing school
after the divorce at age thirty-nine, if you can believe it.
How to describe the gloominess of the hospital at this season?
Little worse than its familiar, jaundiced, institutional gloom,
in some ways, but it is more poignantly melancholy,
doors adorned with droopy silver wreaths, a poinsettia
dropping its leaves on the brightly-sanitized nurses' desk
as if it were coming down with something.
Every effort at seasonal cheer serves only to clarify
its inherent joylessness, just as all the holiday schmoozing
on the ever-running TV sets, the enforced jollity
of Toyota Sellathon commercials and celebrity chefs
baking caramel-gingerbread men on the morning show,
makes us feel more empty-hearted, fearful and alone.

2. *What is light?*

That part of the spectrum of electromagnetic radiation visible to the
human eye is known to us as *light*. It propagates through space as
electromagnetic waves but strikes the cornea as particulate quanta,
called *photons*. Its famous speed surpasses 186,000 miles per second
though I once attended a lecture where a physicist explained how
her team had created *slow light* within a Bose-Einstein condensate
of gaseous rubidium cooled to a few billionths of a degree above
absolute zero. They could actually push frozen photons back and
forth with an array of specialized lasers, like children playing with
toy cars. Brilliant, if somewhat impractical.

This is the second acute illness I've suffered in a year,
the first a siege of fever, cough, night sweats, fatigue
that simply would not abate, week after week after week.
For two months they scanned and probed and cultured,
seeking a culprit while ruling out a hundred maladies
of dreadful consequence, which is good, which is wonderful,
though uncertainty can itself become a type of illness,
or a handmaiden to illness, and the enigmatic diagnosis
under which I waited was hardly coined to reassure.

Fever of Unknown Origin: great name for an album,
John said, which is true. Thanks for that, John.
But mostly when you mention it people look at you strangely,
they ask, "Is that a real thing, I mean, what is it?"

There's a scene in one of my favorite Godzilla movies,
Destroy All Monsters or maybe *Invasion of Astro-Monster,*
when a gleeful Japanese scientist announces
that the mysterious creature just then ravaging Tokyo
has finally been identified: "He is called—Monster X!"
As a big reveal, this leaves a few things to be desired.
As scientific information, it is precisely as useful
as a diagnosis of Fever of Unknown Origin.

Eventually I began to feel better, the fever faded down
and the infectious disease team finally decoded
my cocktail of nastiness, the primary malefactor being
a virulent strain of the Coxsackie B enterovirus.

Coxsackie: it's a town on the Hudson River south of Albany,
where they first identified the illness, back in the 1940s.
I've seen its bright green exit sign a hundred times
and now it's inked within me, a bastardized Algonquin word,
possibly meaning *owl's hoot,* possibly nothing at all.

So much of medicine is translation disguised as insight.
You tell the doctor what's wrong with you in English
and she tells you back in Greek, as the joke goes.
Which is not to say that words can't taste like medicine.
Placebo, in Latin, means *I shall be pleasing.*

 4.

When the iodine dye enters the IV tube it spreads throughout my
body like a warm typhoon; the CT scanner is molded from white
plastic smooth as the cartilage of an airplane, it hums and whirs, my
own private flight to nowhere.

After she injects a string of minuscule bubbles into my vein, the
technician and I see them carom speedily through the chambers of
my heart—*there they go!*—blood racing furiously throughout the
body, exhausting just to watch the great muscle clench and pulse, a
gray homunculus on the ultrasound monitor.

For hours I endure the embrace of the MRI machine, a tube into
which I am inserted as into a Neanderthal burial pit, a casket-sized
blast furnace that bangs and grinds, piston-like noises that down-
shift to resemble mystical voices chanting, as if death were a pulver-
izing music.

Fascinating, the delicate scopes, prisms, Zeiss lenses, all designed
to examine the eye by mirroring the eye's mechanics, refraction,
dilation, fluorescein angiography, the pressure tests of tonometry,
the Ishihara book of pseudo-isochromatic plates to screen for color
blindness—they've shown it to me so many times I have it memo-
rized.

Push the button when you see a flashing light.

Cover your left eye. Look for the star. Follow my finger.

Don't blink.

5.

There's something wrong with my optic nerve.
The doctor points to an inscrutable cloud on the screen,
perhaps an autoimmune issue, possibly a meningioma,
a tumor on the delicate lining between the coarse sheath
and the nerve itself, or some unclassified inflammation,
perhaps neuritis, possibly triggered by the Coxsackie virus,
which has been known to skulk and malinger in the body,
leaping out to ambush unsuspecting organ systems.

Sometimes, when my sight falters, I see fireworks
pulsing on the eyelid's screen, or a ring of blue dots
the color of *Morpho* butterflies in a Costa Rican jungle.
But mostly it is darkness. I rest, I wait. It comes back.
The world rebuilds—an image of the world—pixel by pixel,

though my visual field remains a fractured mirror,
any stress and it fades, like a silent movie, to black.

Today's diagnosis is more lyrical than the last: *amaurosis fugax*,
which means neither more nor less than *fleeting darkness*,
episodic blindness, though the doctor dislikes that word,
blind, preferring TVO—*transient visual obscuration*—
which is itself obscurative, a label of scientific precision
intended to disguise a general truth, a forest hidden behind trees.

Amaurosis fugax: sounds like a Swedish heavy-metal band,
John said, TVO could be their breakout hit,
and I appreciated, yet again, his effort at lightheartedness,
as I appreciate all the efforts undertaken on my behalf.

I appreciate the orderlies, the techs, the four a.m. nurse,
the kindly Haitian man who trundles his snack-time cart
of saltines and tiny apple juice boxes around the ward.

I appreciate needles and Jell-O and *Family Feud,*
I appreciate bottled water, I appreciate diligence,
I appreciate Antonie van Leeuwenhoek
for inventing the microscope and discovering the world
of *little animals* we call *microbes* and *bacteria,*
I appreciate the elegance of the computer images
that resemble gray-scale Gerhard Richter prints
revealing the fine, fluvial network of veins
that feed the spore-field of my brain, a spongy globe
of blood and cerebrospinal fluid riven with organic wiring,
nerve pulses conducting their ontological wizardry—

let there be light, let there be matter, let there be
Miami on a rainy Thursday forever and ever, amen.

6. *What is the eye?*

Human eyes can differentiate up to ten million colors though the
mantis shrimp deploys nature's most complex color vision system.
Trilobites, extinct denizens of ancient seas, formed hard crystal
lenses from calcite. Compound eyes combine a huge field of view
with terrible resolution—if we had compound eyes, like bees or
houseflies, they would need to be dozens of feet in radius to match
the simple eyeballs we possess.

The eye's interior cavities are filled with gelatinous goops, properly
called *aqueous humor* and *vitreous body*.

The lens is suspended from the ciliary muscles by a transparent
ligament known as the *zonule of Zinn*.

Cornea, pupil, lens, light proceeds through its gateways one after
the next, falling at last on the retina, which, as in a fairy tale, trans-
mutes a pattern of photons into electrical pulses, shuttled along the
optic nerve to the lateral geniculate nucleus, a data-processing sta-
tion in the thalamus, which refines the transmission en route to the
visual cortex, in the occipital lobe of the brain.

The brain controls the nervous system, which controls the body,
like a marvelous octopod trapped in a bumptious robot.

The eye is where it—the nervous system—surfaces, like a prisoner tunneling beyond the walls to freedom, where it crosses realms, like Charon poling across his river, or Janus, the gatekeeping god, who looks both ways.

7. *What is vision?*

Last year, Elizabeth and I viewed an exhibition of paintings intended to illustrate the collegial rivalry among Dutch genre painters of the seventeenth century—it was their Golden Age—though what it really demonstrated is the enigma of talent. The child watching the woman scrape parsnips has a face like a parsnip in *Woman Scraping Parsnips, with a Child Standing by Her,* Nicolaes Maes, 1655; and so on—Gabriel Metsu, Jan Steen, Gerrit Dou—canvas after canvas of windmills and rutabagas until you arrive at the work of Johannes Vermeer. We don't know every detail of Vermeer's life but it was ordinary, provincial, delimited by Dutch propriety. He was never famous and left his wife and eleven children a mountain of debt when he died at age forty-three, having completed perhaps three dozen paintings in his lifetime. He was about twenty-five at the time of *The Milkmaid,* which depicts a stout, placid woman pouring milk from an earthenware jug for the making of bread pudding, to judge from the torn loaves scattered on her table, in a drab room with walls of pockmarked plaster. The maid is wearing a bonnet and a vivid blue apron, there's an old-fashioned foot warmer behind her, some figurative Delft tiles, everything commonplace, elementary, and yet it evokes the bewildering realness of the real in a manner unknown to his peers—their mutual influence is far less remarkable than Vermeer's luminous virtuosity. The painting has been interpreted as a tribute to domestic virtue or subliminal eroti-

cism but it is actually a testament to art as an act of witness, a form of scrupulous attention.

Ut pictura, ita visio, Kepler wrote—sight itself is a picture. Galileo built his first telescope in 1609 and Kepler provided the optical theory behind double-convex lenses, while Van Leeuwenhoek, looking the other direction, glimpsed microbial heavens implausible as the moons of Jupiter. (It was the Golden Age of optics, too, the Scientific Revolution.) As luck would have it, Vermeer lived across the street from Antonie van Leeuwenhoek, a former cloth merchant whose meticulous lens making arose from a retailer's desire to determine the exact thread count of his fabrics; art historians debate whether he may have provided Vermeer with a *camera obscura,* an optical device designed to project an image of perfect visual accuracy onto a screen, with which Vermeer could have traced his compositions before painting them on canvas, as if reliance on such technology would tarnish his illusionistic genius, as if vision were entirely synonymous with eyesight. *Camera obscura* means *dark room,* or *dark chamber,* in Latin. Photography would not be invented for another two centuries but the photographic *camera* takes its name from this predecessor. Both devices are simplistic imitations of the human eye.

The Dutch exhibition had been curated by a French museum but we saw it at the National Gallery of Ireland, and we were distracted, that day in Dublin, by news of a catastrophic hurricane bearing down upon our home in Miami, four thousand miles across the Atlantic Ocean. It was maddening to watch from afar, helpless, numb, parsing the wormlike mass of deadly potentialities, meteorological doom noodles, and as I slipped through a side door to check an incoming text I was filled with foreboding and startled to dis-

cover myself at the back of a conference room where a young Irish-woman in a sea-green sweater was holding forth to a group of older men seated around a table covered in documents and tablets. She was a passionate teacher, explicating Vermeer's work in vivid and minute detail, and it took me a moment to grasp that the men were blind. Their booklets were Braille catalogs and the tablets small-scale models designed to translate from visual to tactile, a way to envision painted images with their fingertips. It was our son texting, just then, to say that we were late to meet him for a pint at a pub in Rathmines, and I barely had time to suggest to Elizabeth the mystery I had stumbled upon—the blind men, their vivacious young guide, the skillfully-modeled simulacra—when the entire group of them filed into the gallery. "The room is thirty meters across," she was saying, "and the paintings are hung head-high from the floor, about six paces in front of you, and the first from the left, completed circa 1658, is *The Milkmaid*." Mirroring the milkmaid's concentration, the sightless men attended to their task, conceiving a picture, composing in the jewel-box theater of the mind an image of an image of the world. "And now," she said, "I will try to describe to you Vermeer's extraordinary use of light."

8.

Allow me to apologize for my self-absorption. My virus
is your virus, ours is a virulent commonwealth.
We breed them together, refine them, borrow them
from friends and strangers, camels and bats,
as my body fights its infection the global corpus
combats our latest invader—retrovirus, ebolavirus, coronavirus—
we are besieged, we sicken, we counterattack, we die.

But illness leads you inward, away from the tribe,
the clan, the calculus of multitudes
vs. singletons that constitutes American thought.
Interiority is a mode of social distancing.
Here, in the hospital, I am me, alone, a being
frightened of its own mechanical failings,
like a bystander trapped in a broken elevator.
I feel, to myself, like a construct, a built thing, a city
in which I encounter my own bacterial hordes as strangers
passing silently through a maze of alleys.
I watch my heart pulsing and I do not think
That is me, there beats my engine,
I think, *Ah, skillful machine,* as if it were an iPhone.
I feel the body's otherness all around me.
I compose the urgent letter in its envelope,
I carry the scepter in its keep.
It is a prison and a vehicle of emancipation, a strong horse.
My legs trot and canter, my hair grows unlicensed,
my lungs expand and contract automatically.
I am me, alone, but how do I happen
to be here? What am I
if not my body?
Who am *I* if not that *it?*
The doctors tell me the many ways I might die
but not how I come to be alive,
existence is a fever of unknown origin,
a pandemonium of desires—
I want to live, I want to breathe, I want
to see as vividly as Vermeer and as broadly as a common fly
and as encyclopedically as the mantis shrimp
though I cannot understand why

it would need to differentiate ten million colors
or how anyone could measure its capability to do so—
the Ishihara test?—simple questionnaires?
I want my heart to shake its defiant fist at the sky forever.
I want my soul to swell with sorrow as with joy.
Most of all, with a desperation that embarrasses me,
as if I had been jailed a decade, I want to go home.

9. *What is the soul?*

I am not a virus nor an elevator nor a meadowlark.
Something makes me human.
In which cell or organ does it reside, the soul?

Da Vinci located it in the optic chiasm
while Descartes was a partisan of the pineal gland.
Aristotle searched first the liver and then the brain,
dissecting cuttlefish, rays, snakes, a peacock
and possibly a zebra,
before deciding it lives within the heart.

Perhaps so.

But I imagine it not as a humor or an aura
but an essence flowing
from one vessel
to another—it is her pool of milk
and everything it touches,
the act of pouring
and the amplitude of its fall,

it is sunlight
washing the walls of a room
adjacent to the kitchens in Delft and it is,
quite possibly, the milkmaid herself.

The master has gone off to paint
and she is absorbed in her task, mindful
not to spill a drop.

3

BUKHARA

i.m. Tony Hoagland

In the dream I'm talking to Tony, weeping,
a hundred questions on my tongue
but all he wants is to gaze upon Bukhara.

Bukhara? What does Tony know about Uzbekistan?
I'm trying to see it as it truly is, he says,
towers and minarets, dawn on the celestial blue

domes of Bukhara, its knotted alleyways,
the taxi drivers' ancient grievances,
the endless human hungers and delusions

of Bukhara. Tony was a dangerous man
because truth was his mission and the truth, well,
there are softer blankets to swaddle in.

Laying one's heart on a platter is risky business,
Tony, the scimitars of Bukhara
are infamously sharp. But what's a meal,

he says, without a little organ meat?
Tenderness, a knife through butter—try it,
you'll see Bukhara in a whole new light.

Tony is not alone, I notice, on his stony hillside,
there's Tom, Lucia, J.D., friends and poets,
a cohort of the dead assembled outside Bukhara.

Tony is—what?—preaching, offering prayers
for the sunrise glittering upon Bukhara,
blessings, lessons, homilies?

Tony was trouble because he was always teaching us
how to ride a bicycle (even in Bukhara)
and felt nothing but contempt for training wheels.

Emotional training wheels.
The bicycle—of compassion? Of Bukhara?
No, contempt is wrong, never contempt—

bemused acceptance, tolerant disdain.
Tilt of the head, impish smile.
You see how it is, even in Bukhara, you see?

But whatever he's searching for now,
whatever he's struggling to express, eludes him—
Bukhara, Bukhara, Bukhara—he's whispering

something about sunrise and the abacus
of time, about words and the inarticulable
splendor of Bukhara, ravishment and awe,

the sun's adoration written upon the rooftops
of Bukhara in a thousand ancient scripts,
about passing forward the great mystery—

BUKHARA. We both know what I mean
without either of us ever being able to say it,
don't we, Cam? (Oh, he was one of the few

who called me that!) But listen, Tony,
I'm still worried about you, over here in . . .
Bukhara. Please be careful, stay safe.

The imp again, the playful smirk. Bukhara?
Is that the preferred euphemism now?
Listen, Cam, nobody wants to be the butter,

but somebody has to, no? There, he gestures
suddenly, look there! A great caravan
was setting out through the gates of Bukhara

along the old Silk Road, camels and packhorses
sliding toward the horizon of whatever
lies beyond Bukhara, a realm

beyond praise or calculation, and I knew then
that I would never again gaze upon the legendary
city of Bukhara resplendent in high desert sunrise,

and never again see or talk with my friend Tony,
who knew little of caution, or Bukhara,
and much about—let's call it what it is—the soul.

POEM ENDING WITH A LINE

FROM ROBINSON JEFFERS

Sifted from the dust of stars, from atom-drizzle,
torn from the hem of the garment,
forged from, molded from, wedded to, alloyed with, braided
and cast down among shoals of river gravel
in a wild dominion such as this,
such as this—

I am not dead; I have only become inhuman.

THE FIRE

A young man wakes in a burning house. Tears throttle his eyes, he cannot draw breath, everything is smoke, darkness and fire. He tumbles from bed and crawls the long hallway toward the door; the door is locked, he has no key.

Where is the window, he thinks, but the heat is too intense

and already he is lost.

Whispering his mother's name, he huddles behind that door where firefighters find him, his powerful heart—which nine days later will pump new blood through a stranger's body—still beating.

Why should I startle so at death's brisk fretting of ringed fingers upon the sill?

This house is not inviolate, it never was.

City of the worm, city inside the atom, life requires death's conniv-ance, does it not?

Stars are not the glory of heaven revealed through pinpricks in the fabric of night, stars and darkness are sewn from one material. Zero is a numeral, all stones may be gravestones, from conception we are water turning a wheel, creating what shall be forfeit, grist into meal, life into death into life, and so forth.

Surrender to the process, wisdom bids us, bind your soul to eternity by embracing loss.

Well then, go ahead and grieve, but don't ask me

to stop knocking at the door—wake up, the house is on fire, the house is burning, it always was.

Wake up, my darling boy, wake up.

THE UNBROKEN FIGURE

What we've relinquished circles; and though we are rarely a center of
these orbits: they trace around us the unbroken figure.
—RAINER MARIA RILKE

Why perpetuate myths about fig leaves and apples
when we ourselves are the garden—
and the serpent's tongue and the unforgiving god

and the naked bodies we have no choice,
as with the knowledge that would clothe them
in reverent obscurity, but to desire?

What calls us here, what carries us across the threshold
into existence, what breathes life into a handful
of dirt and casts it staggering along the orbit of its fate?

Maybe the sun has a message for me after all,
a message written in silver intaglio
long after the molten gold of midday fades.

I stand abased before its annunciation, this light
that carries itself like a herald from the king,
acknowledging its command to waste nothing,

never to misstrike the chisel,
to make of each rough block some essential shape,
of each page a poem fateful as a star.

Make it beautiful and true, that's all,
that's all. I've done what I can—
take these words, plant them, and tell me

if an apple tree grows there.

THE HALF-WRITTEN CARD

Reading again the work of a poet whose work
inevitably shames me for my eagerness
to accept simplistic fixes to sophisticated problems
I recognize, all at once, the long-hidden flaw
in a poem I have been working on for years
and considered to be finished
by pretending to believe it was actually finished
and not merely abandoned in shallow water
as with a lovely seashell
inhabited by a live and intractable whelk,
and go to my desk in the darkness
to make the necessary revisions
only to find atop my notebook the half-written card
to my aunt whose husband has died.
I can't find my way, somehow, to finish it.
When I relayed the news to my brother
he said, "No offense intended,
but even in my deepest childhood memories
I think of him as a very old man.
It seems impossible that he was still alive."
Impossible, yes. Alive, dead. Yes. Impossible.

THE CAVES

I.

Talking with Jerry Stern about the Angel of Death
and the Delaware River, he's remembering in lyrical detail
a house he bought for $3,000 in nineteen sixty-something,
old colonial built from stones the size of suitcases
on an acre of land for his tomato plants and zinnias,
squash vines running right to the water's edge.
For a decade we've been lunching together
during Jerry's winter pilgrimage to Miami Beach,
though it's easier now to bring some corned beef sandwiches in,
the deli is hard to navigate and Jerry can't hear a thing,
so we're eating in Jerry and Anne Marie's apartment
overlooking the moored sailboats on Biscayne Bay.
Six weeks after he sold that house, Jerry says,
the guy who bought it dropped dead
from a heart attack or what have you—six weeks!
Now, the Angel of Death is a shrewd customer,
famous in the tradition—it's Malach ha-Mavet
according to rabbinical literature—
but could it be he made a mistake in this instance?
Was he looking for me, Jerry asks, gesturing impishly
with a gherkin, but got that poor schmuck
out harvesting the last of my beefsteak tomatoes?
Jerry's mind is a boardinghouse full of ghosts,
a polyglot Pittsburgh of the come-and-gone,
from Andy Warhol to his own immigrant father dancing
the kazatzka in the kitchen. Victories and defeats

don't mean much to him anymore, but I'm pretty sure
it would satisfy all of Jerry's worldly desires
to pull a fast one on Malach and sidestep his fate
by means of a serendipitous real estate transaction.

2.

After lunch I cross the bay to Tom's workshop in Little Haiti,
driving along blocks of painted storefronts depicting
risen spirits and heroic saints and cemetery angels.
More and more of the people I find myself thinking about
turn out to be dead. Old friends, legendary musicians,
writers I had always wanted to meet and never will.
Jerry is ninety-four, I'm fifty-seven, Tom's granddaughter
is only two months old—last week her mother
skipped out of rehab and took her away to parts unknown.
So, one reason Tom and I work all afternoon
stamping ink onto paper with his hand-set letterpress
is to distract ourselves from looming shadows.
Art makes a shape in the void. I don't know how
else to say it. Everything around us is vanishing
but when Tom feeds fresh paper beneath a roller
primed with ink spun lustrous as syrup
something new comes into being, something never before
seen or gossiped about or cherished or disdained,
a figure, a gesture, a glyph, a totem, a shape
that is always the same, no matter how it changes.
In the caves you recognize it immediately: the purple horse,
black handprints palmed across water-sculpted walls,
herds of elk and bison daubed on undulant stone.

The red deer at Covalanas are 24,000 years old.
In the dark they surround you and are surrounded
by suggestive absences, a world of *luz, oscuridad y sonor,*
the guide says, whispering us forward through time.
Their delicacy is such that to touch any part
of the cave wall would be an act of criminal vanity,
but if you could graze the flank of a single animal,
place a thumb upon one of their calcified thumbprints,
you would connect to the unfathomable
hungers of the Ice Age. Our erudite guide, Joaquín,
turns out to be a distinguished archaeologist,
understanding this cave has been his life's work,
he wrote, quite literally, the book on it.
Six weeks later it arrives in the mail, and I send him,
in return, Anne Marie's book of poems *Red Deer.*

3.

Coming home from Tom's today I watched a young man
perform an unusually passionate dance routine
across from the Chevron station on NW Second Avenue.
He did not appear crazy or lost or abandoned,
just ready to get dancing to some Kendrick Lamar.
Now, from my window at twilight, the porter weed
burns like a purple fire down the elongated fuse of its stem,
entwined with the rapturous, violet-flowered pea vine
and the burgundy leaves of a spraddled croton,
and it comes to me that this is among my handful of triumphs,
this glorious, bee-haunted, overspilling bouquet,
a gorgeous mess tumbling from the bamboo trellis

I have inadequately wired to the fence posts.
Emerging on the cliff face from the cave at Covalanas
there is a long moment when you hang suspended
between the memory of its mineralized, cinematic darkness
and the dreamlike intensity of sky, sun, wind,
the intoxicating Braille-work of the senses.
The view is a fairy tale of Cantabrian peaks and valleys,
meadows dewed with freshly-crushed diamonds,
stone-walled pastures from one of which rises
a xylophone of tin bells as a flock of tiny sheep
scurry into line at the command of a white dog barking
its idea of order. What sent them to the caves
is what keeps Jerry writing—he's publishing two books
in this, his ninety-fifth year on the planet—what drives me
back to crank the Vandercook No. 4 at Tom's print shop
with its odor of mineral spirits and warm machine oil,
its endless drawers of fonts and jigs and spacers
for setting blocks of type, binding every letter just right.
We are alive. That's all. Our hearts, however briefly,
join their tattoo to the din, and one response
is to honor that mystery in pirouettes, in bells,
in scrawls of manganese and iron oxide.
Truth be told, my talent as a graphic artist
is marginal at best, even Tom only trusts me
to hang the freshly-run prints on the drying rack.
Red fear, green desire, purple awe—I can name
the colors but I can't bend them to my will
or match their pigments to my handprints on the wall.
Words are my horses, my aurochs, my antelope,
crude characters inked on paper, primitive tools
for the glorification of such creatures.

THIS IS A POEM

It is a dramatic claim,
a declaration!
As when Xerxes
asserted his dominion
over all cities
and lands of Greece,
which occasioned
war, invasion, death,
destruction,
victory and defeat.
If this is, in truth,
a poem, what
should go into it—
these here, those
over there?
Have you got any
file boxes
to rummage
for tropes or idioms?
Back to Xerxes.
Though his army
was as massive
as his fleet it was not
enough. It never is.
After Salamis he
withdrew with what
remained of the navy,
leaving Mardonius

to lead the Immortals
into battle. O,
it is a large claim!
Make it remembering
the catastrophe
awaiting the Persians
on the slope before Plataea,
taunted, beaten, hacked
to pieces in the dirt.

THE SUN

Sound of the coming rain, sound of the commuter train percussive
as tenpenny nails, sound of the electric fan, sound of thunder
booming out, very close indeed.

Sound of my voice echoing in the snail-shell byways of my skull,
my secret voice, liturgical, talismanic, my snail-song voice.

Sound of the downpour like a shovel in gravel, like sand thrown
against a doorway, lightning flashes suddenly with the sound
of a padlock snapping open, sound of a car motor cranking,
sound of the El slowing to a halt at the station, sound of the
trees, the grass, tomato plants growing along the side of the
house, thirsty roots thankful for water.

Sound of fat droplets downgrading to a drizzle, sound of a bird
or cricket, some squeaking creature like a faucet dripping
lemon juice, sound of a drape cord ticking in the breeze,
sound of thunder retreating like footsteps descending into
the basement.

Sound of the city resuming its floor show, sound of the clouds
building their castles, sound of the rain stopping now.

Now we exist in the present, rain-glazed, wet, wetter than before,
glazed with water-that-was-rain, remembering that this too
is the Now-Which-Has-Already-Passed, the Now which
is happenstance, is the shell, is fallen petals, smoke, the
Tenebrous-Fire-Touched-Unrecoverable Now.

Now I see in the air a spirit—is it my own gold-battered soul or
 sunlight in the crown of the elm tree, hovering?

Now the sun is out, in which we enter used bookstores and discover
 a line from Walter Benjamin or a T'ang dynasty poem that
 changes our life or more probably doesn't but makes us think,
 at least for a moment, about changing our lives,

the sun in which workmen align wooden planks on scaffolds, in
 which a baby sleeps snugly in its gentrified papoose, in which
 old women come out from beneath their umbrellas and
 young couples walk into diners to eat omelets and bowls of
 asparagus soup.

The sun, a great place not to visit.

The sun which shines upon the transit buses up and down Stoney
 Island Avenue no matter how intense the shit becomes.

The sun whose light as it filters through the trees is elegant and
 lovely, infused with grace, it is good to be alive in young-
 leafed summer.

The sun in which I pass an ancient closed-down Woolworth's
 remembering the pleasure of the bygone pet department
 there, how the green parakeets would fly loose and perch
 squawking on top of the light fixtures and merchandise—

once, long ago, I asked the saleswoman how it happened and she
 said, touching my arm, deeply moved, *Thoughtless people
 leave the cages open.*

4

THE HILL

Summer

1.

Running in circles—
the black dog, yellow flowers,
day's eye opening . . .

How to distinguish
the porcelain-berry vine
in earliest June?

Echoes of echoes—
turtles basking on warm stones
in late June sunlight.

So the raspberries
turn out to be wineberries—
less sugar, same thorns.

June into July,
huge beds of tiger lilies,
morning on the hill.

Two pink peonies
bent to the soil by rain,
the black dog barking.

2.

The black dog pulling
at the leash by the meadow
where the deer emerge.

Magnolia blossoms
in deepest, rich, green, green dusk—
glory of July.

Glory of July—
fireflies more beautiful
than the fireworks.

It's taken over
Larry's old tomato patch—
a crab apple tree.

Whoever planted
this bamboo was a husband
to profligacy!

We cannot know it—
insatiability—
as sunflowers do.

3.

Untended flowers,
azaleas smothered in vines,
richness, wildness, loss.

Wild and untended,
how poems grow in the mind—
hot day in August.

Tree house overgrown
with vines, the kids home all day,
playing Nintendo.

Is it still summer—
yellow leaves in shaggy grass,
age spots on my shins.

Bees and bumblebees
hovering over clover,
bumblebees and bees.

Cool night, late August,
and the porcelain berries
slowly turning blue.

Autumn

I.

Rain in September—
no one remembers the toys
lost in summer grass.

> Full of leaves and rain,
> swimming pools beneath blue tarps
> patrolled by spiders.

> > Patrolled by spiders,
> > the last of last year's cordwood
> > stacked by a stone wall.

Autumn, falling leaves,
the child feared lost returns
from the woods at dusk.

> Fallen locust tree
> not yet covered in ivy,
> October evening.

> > Indifferent to rain,
> > old jack-o'-lanterns rotting
> > in the ivy patch.

2.

Lurid blue tangles
of porcelain berries ring
the rhododendron.

> Last spring's azaleas—
> brown tassels jeweled with droplets
> of November mist.

> > Seedlings and brambles
> > in the widower's garden,
> > deer feeding at dusk.

Castle sentinels,
the heads of old hydrangeas
swivel in the breeze.

> I have never seen
> anything as blue as these
> porcelain berries!

> > So hard to describe
> > the way everything dissolves
> > in November mist.

3.

Through the long autumn
my childhood is falling
lazily—oak leaves.

 Green moss on the roots
 of autumnal trees—the way
 things are in this world.

 Late autumn, the elms
 resemble stringless harps strummed
 by December rain.

First snowfall—I watch
the ancient dogwood glisten,
imagining spring.

 Years ago, we wed
 in a cloud of white flowers
 beneath that same tree!

 Everything trembling
 in the slightest of breezes,
 day after Christmas.

Winter

1.

Winter light, fresh snow,
the trees have grown accustomed
to their nakedness.

> Winter light, one crow
> in the pine, one in the beech,
> talking back and forth.

> > Brown vines and brambles
> > climbing the rusted swing set,
> > January dawn.

Vase of sunflowers
by the west-facing window,
snow coming down fast.

> Pencil talk all day,
> now the notebook dreams
> in winter moonlight.

> > Winter, and the stag
> > caught on the barbed-wire fence
> > bleeds into fresh snow.

2.

Walking the black dog
through every puddle of slush,
February dusk.

 Walking the black dog—
 rock salt and deer prints in snow
 just turning to sleet.

 Ice forming at dusk—
 an old man I've never seen
 says "Good seeing you."

Black walnuts rotting
in muddy leaves—my childhood
wells up from darkness.

 Cables of ivy
 around the old hollow oak—
 somebody's cut them.

 Ice forming at dusk,
 the old man walking away,
 winter grass, its burrs.

3.

Watching wood transform
to ash-fall, wondering what
comes after this life.

Sitting by the fire,
thinking about combustion
and taking a nap.

That old snow shovel,
what is it thinking about
out there in the shed?

After all these years,
will it see another spring,
the old hollow oak?

Still there are moments—
winter stars through bare branches,
the dog's joy, my own.

New buds on each branch,
the silence of the beech tree,
snow falling at dusk.

Spring

1.

Deer tracks in spring snow
and the old yellow salt box
where the road gets steep.

> Through barren branches
> rain clouds streaming east to west,
> cold day, early spring.

> > Deer tracks in spring snow,
> > dreaming our old wolfish dreams,
> > the black dog and me.

Is that phlox or stock,
gaudy purple stalks of it
blooming all alone?

> A perfect half-moon
> in the arms of the budding
> Japanese maple.

> > On the hill, the trees
> > remember the old forest
> > and shine, quietly.

2.

Warm week in late March,
the apple orchard heavy
with ripening buds.

 Those apples growing
 on the south side of the hill—
 what do they taste like?

 Walking the black dog
 I'm thinking about orchards
 and neighborliness.

Ah, azaleas, ah,
profusion, a world ablaze
with stars and flowers!

 So many flowers
 I do not know the names of—
 kindnesses at dusk.

 Don't forage for them
 and they come unheralded,
 mushrooms and haiku.

3.

Opening a can
of sardines without a key—
the wind in the reeds.

Too hot and too cold,
April seed-wings cascading
into my teacup.

Ungardening—so
the mind grows out of itself,
all thorns and blossoms.

Old, bleached-out bamboo
on the woodpile—I'm reading
Basho in May sun!

Wine and peonies,
against time's ruin this brief
intoxication.

Beneath the beech tree
in the backyard the black dog
running in circles.

5

$14,000 WATCH

Got caught staring
past the guy three stools down at the bar
and he says *You like it, huh?*

flashing his wrist,
Fourteen grand,
and I nod, not wanting to say

I was watching shadows flicker
across the wall behind him,
thinking about human suffering.

TRIUMPH OF THE GOBLIN

Days I am the lightning storm, merciless in my judgment.
Let the fools choke on the grease of their ignorance.
Let dogs devour the sweet pineapple in its cans.
Let the politicians rot in hell.
But the beauty of the land shames me, it is
preposterous and immense and I feel too little love for it
in my heart, I am worn down.
Days I walk among my countrymen and believe
all will be well, brothers and sisters,
let campfires blossom across the valley, let us mingle
our herds together. Days I think
god help us
but know that he will not, we must
rely upon ourselves
and from the airplane it should be clear,
even to Thoreau, that we are trying.
This gouged, that sprung, those stripped bare.
New highway spurs leading nowhere
stand as proof carved into the raw, red dirt
of belief in our continuing destiny—
the future shall be diversely out-parceled,
the future is a mixed-use project.
Farmland, ex-urban dross, dam-fed lakes
glinting like mirror-glyphs stenciled
among rough hills. The meadow
behind the mall remains
the fringe of a wilderness in which beasts of prey
stalk a vanishing claim. Carpet mills,

distribution centers, spoked boulevards which
even in the most forsaken municipality
feature nail salons, psychics, and semiautomatic weaponry.
I have good reason to believe
it is the *Festival of Shrimp* this month at Red Lobster
and I am hopeful that may suffice but who
can know for sure? Of what
may we speak with absolute certainty?
The Lord created heaven and earth from the void.
There is no such thing as too much reverb in a surf rock song.
Texas, like a lawless, uncivilized lodestone
unbalances the entire nation
but brings to our lives the exultancy of the unhinged.
From up here, the towns resemble fortresses,
primitive defenses against the unknowable earth.
Storm clouds streaming across the prairie, cinder gray
with a black band along the horizon
strobed by distant lightning. You can almost hear
the tornado sirens. Trees filling out, April green,
toy cars on little highways, a model railroad landscape
made of sponge and toothpicks and poster paint,
but no, the places we live in are real,
Okahumpka and Monroeville and East Orange exist
even if the nation remains metaphorical.
Once America was a city on a hill,
once it was a tall ship
carrying the dreams of yearning masses
and another ship packed with the bodies of the enslaved.
Once it was a clearing in the forest haunted by owls,
a wagon train, a factory, a shoot-out at the OK Corral.
Once it was a declaration, once it was an address.

America was never a poem but for a while
it was a novel about a white whale
and for decades it was a movie starring John Wayne
though for most of my life it has been a TV show,
often a sitcom, sentimental and banal,
sometimes a classy drama, admirable if dull,
and now it is a jamboree of grotesques.
Here come the ghouls, the bedazzled militia, here come
the private equity guys sharpening their pencils.
Here comes Ivanka, everybody run!
Here come the Black Friday hordes on their obesity scooters
down the aisles of Walmart, every day is Black Friday
in these pews, open the fucking doors,
asshole! RIP, Jdimytai Damour,
RIP, Sears, Roebuck. Here's Eddie Lampert
looting corpses on the battlefield,
war all the time,
on earth as in heaven,
9/11 24/7.
Here's Alex Jones in his tinfoil hat
shilling the dumb-dumb jelly stashed in his root cellar,
subscribe to save, folks, only $39 a jar.
Harvest of jackals. Harvest of the impaired.
Harvest of virgins blessed by the ghost of Tammy Faye.
Ammo ammo ammo, don't shoot
until the looting starts, I can't breathe, don't bleed out,
amigo, somebody gotta clean these goddamn cells.
The Sacklers feel your suffering, compadre.
Got my scrips in Eff-El-Ay, true that, true that.
Here come the private equity guys sharpening their bayonets,

glue-factory-triple-shift-union-free-from-my-dead-fingers,
Obama death panels overseen by Ewoks,
Four-Twenty Bitches for Q, Antifa noodleheads
spray-painting brass stallions uptown.
Here comes Hillary Prison-ton
in a pantsuit befitting the Queen of Copenhagen
crossbred with which Teletubby—
is it Tinky Winky?—here come the influencers,
the lobbyists, the fact-less autodidacts.
Here come the lawyers with the NDAs
and a sack of Popeyes spicy chicken sandwiches
as a cold wind whips across the parking lot
outside Charles Town, West Virginia,
outside Cody, Wyoming,
outside Lincoln, Minnesota-Indiana-Wisconsin-Vermont,
November wind and the season's first, lace-fine snow
sifting down as evening falls, the blur
of it like an old picture tube on the fritz, yellowing veil
in the window of a closed-down bridal shop
on a street of closed-down stores
beside tracks where the train no longer runs.
A man is throwing rocks at the already-shattered glass
beneath a sodium streetlight
as a familiar figure scuttles into the shadows.
Avert your glance. Keep still. Do not
utter the name of the goblin
for such is the source of his power, the enchantment
by which he binds souls to his dark errand.
There is hardly anything left to break,
and the last of the window glass

is singing a little song of desolation as it falls.
How much longer will the man keep throwing stones?
How far can we stray and yet return?
How deep into the wilderness can you wander, America,
before that song is all we hear?

ON BITTERNESS

Ashes for lye-making, thistle, brimstone, gall.
Cracked rocks in a dry creek bed.
The endless circling of gulls to no purpose.

THE TEACUP

Days I grasp it all in one hand, the sweeping
epic of humanity, as in a teacup, steeping—
and then it slips from my fingers, a Babel
of cultural pistons churning out indecipherable
tools and obligations: the Venus of Willendorf,
Flower Wars, Albert Einstein, miniature golf.

Which version to affirm, panoramic VistaVision
or the countless accounts and sworn depositions—
chronicles, sagas, yarns, gospels, fables—
the porcelain teacup on the kitchen table
or the hundred shards it might become—*oh no!*—
with a touch of the future's careless elbow?

"Come down," she calls, "it's time for tea."
I drink until my thirst is history.

LA CORRÈZE

There are poems hiding everywhere—tiny snails beneath lily pads,
 roses so burdened by blossoms they must lie down upon the
 grass to rest.
Green irises swell the waterway by the ancient village laundry,
 stone pools descending through dog's-head spigots
until the stream spills back into its flower-choked channel,
 cascading into a small whirlpool of star-clustered algae.
The neighboring farm is run by three generations of women, none
 of whom have traveled farther than Limoges, or possibly
 Toulouse.

To escape not from time but time's intermediaries—tyrannical
 clocks, names on maps, calendar grids like battalions of tin
 soldiers.

The enormous canvas of the circus tent, the cinematic vista of
 lives moving forward and back across decades,
history like a clown car, fate like a net spread below high-wire
 artists—these are not the jurisdiction of poetry,
which approves the dragonfly's Dionysian minutiae, and knows
 that every snail shell encompasses a destiny,
and what it means, as the trapeze swings from darkness into the
 spotlight's glare, to reach for the grasping hand.

THE OPOSSUM

We call the local rats "fruit rats" because it makes them sound cleaner and friendlier, less pestilential. In this tropical climate they live outdoors, often in the tops of palm trees, walking along the telephone lines at sunset, eating the various lemons and oranges, mangoes and avocados in backyards up and down the block. Unless they take up residence in my gutters or crawl space I don't bother them, but recently I've found evidence of such trespass, and so set about to kill the offender with old-fashioned, spring-loaded rat traps from the hardware store. But the first few nights don't go well. I set the traps at dusk, and in the morning the bait of old cheese-rind has vanished, with the traps entirely unmolested. Strange. This time I decide to set my three rat traps side by side, with only the middle one baited, and the next morning—disaster: two traps lie wantonly sprung and empty, but the third trap, the middle one, has disappeared. Where? How? It could only be some larger creature that has done it, a neighborhood cat, or a super rat, an animal now injured, or debilitated, which might have crawled some distance into the bushes, perhaps—but I can find no sign of it anywhere.

Chastened, I abandon my rat removal campaign, and within a week forget all about it, or try to, until one night watching TV after dinner I hear an odd noise floating through the window, *clomp, clump,* a kind of straggled clatter, growing louder, more insistent, and I realize, in a flash, that it can only be the noise of whatever animal I have inadvertently snared, a thump every bit as deafening in its accusation as the throb of the "Tell-Tale Heart." Quickly I grab a flashlight and there it is, a young opossum with a rat trap fastened to its left front paw, limping across the deck like a vengeful spirit.

Panic tears at me, fear and remorse, the realization that I had known all along that I would not escape unscathed from this misadventure, that an existential cost would be paid. But there's hope—if I can catch the opossum somehow, if I can release the trap and set him free! I grab a towel as I dash out the back door, thinking to throw it like a net, wondering about scratches, whether possums carry rabies, but he has caught wind of me and begins to scurry away, impaired but still nimble, scooting along the wall and behind the central air conditioner and into a hole scrabbled in the hard dirt below my deck, out of reach. So that's where he lives.

In the morning I remove the decking screws and take up several planks but there is no sign of the opossum. It seems likely this eviction will doom it, and I don't know how it survived this long in such a state—though its kind are nothing if not survivors, having borne their prehensile tails and marsupial pouches from the age of dinosaurs—but I do not hesitate to fill its burrow with dirt, and barricade the entryway with slabs from an old flowerpot to prevent him from returning. There is nothing else to be done. We are bound by what we carry, we belong to what we kill. The porter weed has failed and needs replacing. Tangerines lie where they have fallen in the sparse grass. In the hours before dawn I find myself in the backyard talking with the ghost of Edgar Allan Poe, begging his forgiveness, though even as I lay the first stone upon his grave—not a stone but a shard of broken pottery—I recognize, by the palpable quality of the moonlight on my skin, by the warm tears against my cheek, by the ravishing perfume of night-flowering jasmine—that this life, too, is no more substantial than a dream.

JANE STREET

The mind, when it flowers, flowers as strangely
as the meat markets once blossomed
with carcasses at sunrise by piers along the Hudson
before change transformed forever
that impious parish for which the mind still hungers.

The heart, when it hungers, hungers for sustenance
raw as the sinews the meat hooks sliced through
to hang their carrion flowers in a world of golden hours
vanishing like the fugitive precincts of youth,
the Hundred Years' War of youth.

Estuary tides among pilings at dawn, animal blood
between the cobblestones, time pours itself
everywhere around us, refracting through clouds
of pollen, dust and steam until we are
immersed in the familiar silver of civil twilight.

So this is the city, these
its byzantine veils and velocities,
so this is mercy, a river of sirens, one face
in the window on Jane Street
yours.

THE ABACUS

Our days are numbered,
 numbered and brief.
Time is an abacus,
 time is a thief.

This life, what a whirlwind,
 a cyclone of grief.
Our days are numbered.
 Well, that's a relief.

THE MERCY SUPERMARKET

Everything is alive, everything is shimmering
with vitality—the tomato rootlings
in their fragile sheaths
of soil, oil-colored worms in leaf mulch,
pollen from the burst-open, canoe-shaped pods
of the royal palms caught in the first
imperious shafts of sunlight
rising from the sea.
One flower resembles a puff of red lint,
another resembles a pig's ear,
every petal, in this light, painted with deep lucid
particularity. Seconds flare like fireflies
in a summer meadow
though they are illusory, time is
not a meadow but an ocean to be swum
endlessly by starlight. Days die
and so do we,
banal, tedious, futile to protest
yet still we argue, as if
death was a rental car agreement
whose stipulations might be recalculated
by a helpful service representative.
Most days this silvery half-light is enough
to nourish the fledglings skyward,
to charge the battery
of the heart. And later
night will whisper
encouragements in a language

nobody really understands,
no drama or falsity, just the moon above
the Mercy Supermarket
and the city beating its heart for the numberless,
the unknowable, the unnamed.
Who's with me on Biscayne Boulevard tonight?
Who else is in the market for a pint
of papaya juice, a scruple of compassion?
Would it help if we could itemize
every lost or misbegotten soul,
enter every name in a vellum registry?
Would it summarize my life
to list every object
I have touched with these two hands?
Yesterday I held for the first time
an infant born two months ago in Chicago
with a tiny glitch
in the long arm of chromosome 17,
the slightest of clerical errors,
one skewed letter in an ever-cascading text,
so how useful
can any catalog of particulars be?
Why do we even have them—
hands, thumbs,
a heart,
this jawbone I hear click
as the rusty joints
swing open and closed,
like a drawbridge.
I hear the *thunk, thunk, thunk*
of ideas rebounding like rubber balls

against the sturdy armor
of my skull, ideas tasting of iron
and childhood, like water from a garden hose.
We want so much before it's taken from us,
objects cry out, the things
of this world, they are magnificent,
they glow—the radiance archive,
everything that shines is in it.
Still, the lemon tree levies a tax upon my soul.
Flowers strike their tiny hammer-blows.
The city makes its thousand demands,
the city is a honeycomb
of needs. Stepping over a man
curled like a fetus at the base of a lightpost
with a sign—I HAVE AIDS

I AM DYING

I AM HUNGRY PLEASE HELP—

but the man, even if you wanted to help, is asleep,
or unconscious—not dead, surely?—
splayed amidst the overspill from a trash can
of filth and donut sacks,
entirely oblivious to the flood
of kids still pouring from the high school
around the corner
on 16th Street, the mind recoils
from their sizzling aura
of sass and young-ram bravado,
their cell phones and cartoon umbrellas and eyes
fixed on a future
that does not contain
this broken man, or you, or anyone

like you. But the man is
real, he is
here
right now
wrapped in rain, and you
tuck a five-dollar bill beneath his arm
hoping for a measure of mercy
no larger, perhaps, than a coffee cup,
and though he does not move
he begins, as you turn away, to speak—
Thank you, you are a good person,
may God bless you forever.
Dearest god, I thank you
for this blessing,
though I cannot believe in it, or you.
Nonetheless I honor your name
for allowing me tenancy on this, your firmament,
and I accept its provision as my lot.
If sorrow is the sentence
I will serve it.
If pain is your message I receive it.
Leaves are trembling
in an otherwise imperceptible breeze,
I watch their dance of accommodation and delight,
moved by invisible forces.
So too do I tremble, so am I moved.
Right now, I tell you
I am listening to something that says
let it go, fear not, rise
along with me
into a sky composed of amethyst and copper dust.

It is not a voice, it is not even a bird,
but I am listening.
I believe it may be the light
itself speaking to me,
because the sun has arrived, robed in gold,
as the sun is continuously arriving
at one horizon only to depart from another—
it is perpetual daybreak, do you see,
it is time's corolla,
time's counterweight
to the pendulum of our grief, it is
that all-consuming journey into radiance, the dawn.

Acknowledgments

The American Poetry Review: "The Caves" and "The Moon"

Bigger Wednesday: "Triumph of the Goblin"

Burnside Review: "The Opossum"

Copper Nickel: "La Corrèze"

EcoTheo Review: "The Hill: Summer"

Glimpse: "The Teacup"

Grist: "$14,000 Watch," "Ode to History," "The Unbroken Figure,"
 and "Tugboats on the Chicago River"

The Laurel Review: "The Parking Lot"

New England Review: "The Frog Pond"

New Letters: "Burning the Ships" and "Poem Ending with a Line from
 Robinson Jeffers"

The New Yorker: "At the Ruins of Yankee Stadium" and "The Mercy
 Supermarket"

The Paris Review: "Fever of Unknown Origin" and "Santa Monica"

Rattle: "The Fire"

Sonora Review: "The Sun"

The Threepenny Review: "Bukhara"

Tribes: "Jane Street" and "Night and Day"

"At the Ruins of Yankee Stadium" was also published by Bard Graduate
Center in *What Is Research?*, edited by Peter Miller.

"The Sun" was also published in *Wherever I'm At: An Anthology of Chicago Poetry*, published by After Hours Press/Third World Press, edited by Donald G. Evans and Robin Metz.

"At the Ruins of Yankee Stadium" is for Peter Miller.
"Bukhara" is for Tony Hoagland.
"The Caves" is for Gerald Stern and Anne Marie Macari.

Campbell McGrath is the author of eleven books of poetry, most recently *Nouns & Verbs: New and Selected Poems* and *XX: Poems for the Twentieth Century*, a finalist for the 2017 Pulitzer Prize. His writing has been recognized with a MacArthur Foundation "Genius Award," a Guggenheim Fellowship, a Witter Bynner Fellowship from the Library of Congress, and a United States Artists Fellowship. He lives with his wife in Miami Beach, and teaches in the MFA program at Florida International University.

A NOTE ON THE TYPE

The text of this book was set in Ehrhardt, a typeface based on the specimens of "Dutch" types found at the Ehrhardt foundry in Leipzig. The original design of the face was the work of Nicholas Kis, a Hungarian punch cutter known to have worked in Amsterdam from 1680 to 1689. The modern version of Ehrhardt was cut by the Monotype Corporation of London in 1937.

Composed by North Market Street Graphics,
Lancaster, Pennsylvania

Printed and bound by Berryville Graphics,
Berryville, Virginia

Designed by Soonyoung Kwon